RIGHT PAGE

T0046510

[Music, marking a beat with fist a the table]

My name is Isabel Lewis.
I'm very happy to be here with you.
Lately, I've been thinking–lately,
 meaning the last several years–
What if we could communicate with
 things?
What if things could speak to us in
 their own language?
It seems kind of frightening to imagine
 what would happen if these walls
 could talk, if these objects
 lifted their voices in some kind of
 protest.
I mean, imagine having to manage your
 interspecies relationships and your
 inter-thing relationships–
As if human interrelations weren't
 already enough. As if they aren't
 already extremely energy-consuming
 and difficult to deal with.
It seems worthwhile nonetheless to try,
to try to become sensitive enough
 to pick up on the transmissions
 that come from the materials that
 we live with.

I TURN THE PAGE

How would we cultivate that?

Which kind of practices would we need to engage in?

Maybe practices like loving—like learning from love.

~~If you buy wood and work with it and build something with it, do you have a different feeling for it than you would for the store-bought wooden thing—because you put your body inside of it?~~

Do you think we can learn things from materials?

When you make something yourself, with your hands, does something different happen?

Could we o-
Could we o-
Could we open the channels of co—
of co—
of communication
yEh, uh-uh, eh.
yEh, uh-uh, eh.
yEh, uh-uh, eh.
yEh, uh-uh, eh.
Eh-what, eh-wha-wha-eh-wha
Eh-what, eh-wha-wha-eh-wha
Eh-what, eh-wha-wha-eh-wha
Eh-what, eh-wha-wha-eh-wha
Eh Eh Uh eh eh
Ima read, eh, uh, uh, eh
Ima read, eh uh, uh, eh
Ima read, eh, uh, uh, eh
Ima read, eh uh, uh, eh
Ima read.

[Lewis processes her voice using digital effects, loops, and distortion. Staccato movements begin in her body and she steps away from the equipment and continues in a vigorous dance, weaving between the guests in the room. Eventually, she continues to speak, slightly out of breath.]

I TURN THE PAGE

Do you know what it means to read someone? It's the idea that you quickly and dismissively size someone up. You judge every detail of their appearance, making a quick and definitive assessment of their person and even their character. It's pretty brutal usually, but also humorous and ultimately loving. What if we could think about reading in that way, like reading as being lovingly attentive to another.

[Music]
[Guests socializing]

[Music]
[Lewis produces an ambient yet rhythmic sound by sampling, layering, distorting, looping, and morphing together fragments from medieval chamber music to hip-hop. The effect is like a slow-tempo underwater rave. The music almost reminds you of something but then slips away from recognition.]

I think it's a very rich process to
be fully engaged with things,
even maybe in love … with things.

It reminds me of a story about stories
of love that was told in a gath-
ering of people a long, long time
ago.

~~People are lounging around, the~~
~~wine is flowing, and there is live~~
~~entertainment. Somebody is~~
~~in charge of the strength of the~~
~~wine, and, as the evening progress-~~
~~es, the wine gets stronger as~~
~~the conversations develop.~~ They are
speaking about the true nature
of love and this happens to be a
gathering of philosophers.

And there are many iterations and
attempts to define the best
theory, some more interesting than
others.

One of them that I quite like is the
story of the "Kugelmensch"; do
you speak any German? In German,
the word "Kugelmensch" roughly
translates to "ball-shaped human."
These ball-shaped beings have
both genders integrated within
themselves and feel content and
complete.

They feel so empowered by the magnitude
of the love that they experience
that they challenge the gods,

thinking, "We can create from this love. We can sow our seeds in the earth and actually create life just as you created us."

I TURN THE PAGE

This angered the gods, and the Kugel-
 menschen are punished for their
 hubris.

They're struck apart, and this is
 apparently how we arrived at two
 separate sexes.

According to this story, our profile is the scar we bear of this separation, struck apart

and ever incapable of fulfillment.
The true nature of love here is the
inability to ever feel complete,
to be doomed to roam the earth
searching for that missing half.

[Music]
[Pitch-shifted samples are layered over other
samples, fragments of pop music chopped, screwed,
and reorganized like a mutating body writhing
and swaying. Phil Collins? Ludacris?
I've got—
O o h h!
(H o e s!)
 think twice
it's just another day for you
 I've got
(in different area codes)
 Pa ra dise
 You—
I've got—
O o h h!]

[Music]

[Lewis lowers the music.]

And then someone else tries to begin
their story but is overcome by
an attack of the hiccups—a very
strange form of bodily possession.

So, the rock-star philosopher of that
time, the most rhetorically power-
ful one, Socrates, takes the floor
and starts to deliver his story
about the true nature of love,
claiming that he's heard this
story from a woman named Diotima.

He says that the first stage of love is
about loving one other body,

*[Lewis hones her attention in on a guest and
approaches them.]*

One particular body you're drawn to,
and by focusing on just that
attraction and your libidinal
energies, you learn to love every-
thing about them.

[She kneels before them and sustains eye contact.]

The beautiful, darker bluish-gray rim
around the pale gray iris of your
eyes, and your Romanesque nose, and
the laugh lines, and the particular
shade of pink coloring your cheeks,
the subtle dusting of freckles
around your nose …

You fall.

You fall completely and utterly in love
with this one human for all of
their physical attributes first,
then get to know them deeply,

sexually, intellectually, spiri-
tually, and that love grows inside
you. You are grown by this love
and learn from this love, so that
you're able to expand that love
to a second individual, a second
beautiful creature.
*[Lewis makes eye contact with another seated
guest and weaves her way through the crowd
toward them; kneeling before them, she says ...]*
I TURN THE PAGE

With fire-red hair, and ears that
extend in space far enough for the
sunlight to illuminate. They're
gorgeous! The sun moves through
them and they become even more
red …

as I compliment their beauty. Your
charming dimples …

And you start loving that person as
well …

Just as much and just as intensely
as I love you. This love grows in
me and I grow bigger, so that
I'm able to extend my love from
beautiful people to beautiful
nonhuman things.

I'm able to appreciate the shape, the
texture, of fine and well-made
things, and continue to step up
this ladder of love to beautiful
ideas, beautiful concepts, things
like mathematics, like architec-
ture, like justice. I continue
growing this love until I'm awash
in an ocean of love that spreads
out evenly in every direction,
until I achieve—through this
rational, logical, step-by-step
process—the total love of all
knowledge itself. I become
the ultimate lover in Socrates's
scheme, the philosopher.

Sounds good.

I would sign up for a program with that one-step-leads-to-another logic.

~~I would love to be able to approach my relationships with people in such a methodical way.~~ I don't know about you, but in my experience love is much messier than that.

<div align="right">

I TURN THE PAGE

</div>

LEFT PAGE

Just at this moment, there's a distur-
bance at the door, and a raucous
group of uninvited guests
crash the party. They are led by
Alcibiades. He saunters in and
he's got these fragrant violets in
his hair and he smells of wine
and sweat. He's got these dark
curls that spill over his forehead
and his toga is half falling off
his muscular body.
It's a very sensual and sexy image
Plato is presenting us with here.
[Lewis walks up to one of the recently arrived
guests.]
May I smell you?
Sorry, I know you've just arrived and
I don't mean to disturb you.
You, yes, you.
You've just arrived I know, but may I
smell you?
Salty smell, a human smell, no perfume,
a delicate smell …
Your smell is a total contrast to
Alcibiades's smell after long
hours of drinking, partying,
and sex.
Alcibiades assesses the situation
and realizes that everyone who's
invited is meant to give a speech
about the true nature of love.

[Music]
[A fat bass beat at 65 bpm, like the human heart at rest.
On the downbeat, three tense descending chords, sustained for one slow beat each,
follow one after the other.
A rest for two thick thumps.
The chords, swelling and receding organ sounds sampled from The Roots' song
"Break You Off," digitally processed and distorted, continue in this sequence,
stretching across this, a counterpoint.
"Goodies," in a dragged-out whisper.
Ciara's voice sampled from "Goodies" in a dragged-out whisper.
On the upbeat, the inhale and "my—"
on the downbeat, a chunky "g" sound completes the phrase "—goodies" in an exhale.
Inhale, exhale "my goodies,"
inhale, exhale "my goodies."
beat beat beat
...chOrd... ...chOrd... ...chOrd...
 inhale, exhale inhale, exhale inhale, exhale
 "my goodies" "my goodies" "my goodies"
 beat [rest] beat [rest]
and the beat goes on.]

He stares back at the philosophers and says something like: "You don't know what you're talking about. There is no way to arrive at the truth about love through philosophical arguments. I can tell you the truth about love, if you allow me to, through a story"—and it's specifically his story of love for Socrates that he is referring to.

Alcibiades is inflamed with passion for Socrates's rational arguments, for his rhetorical style; he speaks of its musicality.

It's not how we tend to think about Socrates, but in the eyes of Alcibiades, Socrates is very desirable. Alcibiades says he is internally wounded with this passion. This is how he describes it: "Something inner, something inside of me that is fleshy, I don't know … a soul or whatever it is, feels bitten through as though by a snake."

Everyone's feeling a little bit embarrassed and uncomfortable for Alcibiades, who is essentially exposing himself.

He reveals himself in a very atypical kind of relation for that time and place: Socrates was his teacher. Customarily, it would have been

the older man, the erastes, who would express lust or
love feelings toward the younger counterpart, the eromenos, who was demure, and seemingly self-absorbed and self-sufficient. This erotic connection would serve as the channel for the transfer of knowledge needed to develop the young Athenian citizen.
Here, the script is flipped.
Alcibiades speaks of the passion that he has for Socrates that was never fulfilled. Socrates was never seduced by Alcibiades's beauty, brilliance, and charisma. He remained closed-off to Alcibiades, which of course made the latter ever more desirous of this unbreakable, untouchable Socrates, who didn't seem to be the most attractive guy …
I mean: not that the pug-nosed, bald, and bearded thing can't be rocked, it certainly can. But what makes him unsexy is not so much his physical features—because I could get into that, sure, it could be hot—but the fact that he's so entirely unaffected by everything.
He seems to never be drunk no matter how much he drinks. He wears out his sandals in battle, his feet

becoming bloody and completely
blistered, and doesn't even notice!
He's lost in thought, always.
Wandering the city walls of
Athens, he doesn't hear someone
who's screaming and yelling to
get his attention. He is
completely and totally in his mind
and disembodied all the time.

I TURN THE PAGE

Socrates is transformed in the eyes
 of the man who loves him and knows
 him—into something sensual,
 something vital.

Can you imagine loving that hard?
Being so receptive to another
that you feel inwardly pierced?
That radical form of receptivity
is something that Martha Nussbaum,
American classicist, calls "the
lovers' understanding."

~~The lovers' understanding is an~~
~~embodied form of knowledge, which,~~
~~in the Western canon, has always~~
~~been looked down upon as profane,~~
~~while the platonic love represented~~
~~by Socrates has been so valued.~~

In naming Alcibiades's passionate,
fallible, and fragile form of love
"the lovers' understanding,"
Nussbaum honors his particular form
of love as a form of knowing.

I TURN THE PAGE

Could we apply that same kind of
knowing to our interactions with
all things and with other species?
I think so.

We may not be able to entirely repair
the relationship we have with our
biosocial surroundings, but might
we be able to make space for some
kind of partial reconciliation?

[Music]

[Music]
[The harp sample from Lana Del Rey's "Videogames" floats in and out above a melodic vocal phrase that has been heavily distorted into a drone. Marking the beat is the beginning of a word that remains unfinished, "sp," and a distant wooden tapping sound.]

[Music]

[Music]

[Music]
[Guests socializing]

[Music]
[A slow and syncopated beat, bass, and a metallic slap with an abrupt stop and period of silence. The silence exposes the grainy digital copy of the sound of a dust-flecked record. All of this loops.]

[Music]

[Music]
[Guests socializing]

[Music]

[Music]

[Music]
[Some guests begin to sway to the music.]

[Music]

I TURN THE PAGE